Flowers in Acrylics

Wendy Jelbert

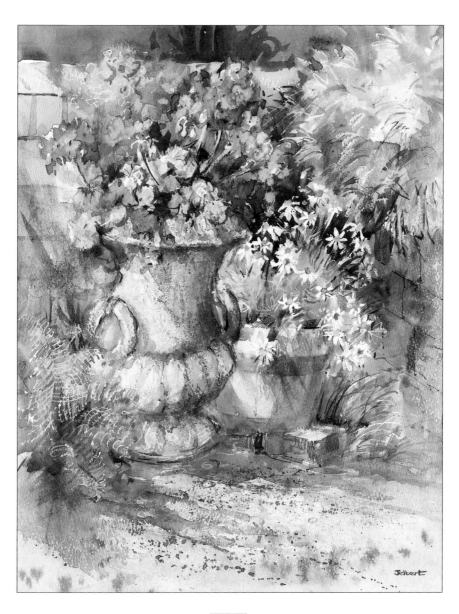

SEARCH PRESS

First published in Great Britain 2009

Search Press Limited
Wellwood, North Farm Road,
Tunbridge Wells, Kent TN2 3DR

Reprinted 2009, 2010

Text copyright © Wendy Jelbert, 2009

Photographs by Debbie Patterson at Search Press Studios

Photographs and design copyright © Search Press Ltd. 2009

ISBN: 978-1-84448-425-6

The Publishers and author can accept no responsibility for any
consequences arising from the information, advice or instructions given
in this publication.

Suppliers
If you have any difficulty obtaining any of the materials and equipment
mentioned in this book, please visit the search press website:
www.searchpress.com

Publisher's note
All the step-by-step photographs in this book feature the author,
Wendy Jelbert, demonstrating her acrylic painting techniques.
No models have been used.

**Please note: when removing the perforated sheets of tracing paper
from the book, score them first, then carefully pull out each sheet.**

Printed in China

Dedication
To my lovely 'flowers': my youngest daughter Rosalind
and her children – my grandchildren – Georgie, Grace
and Lily.

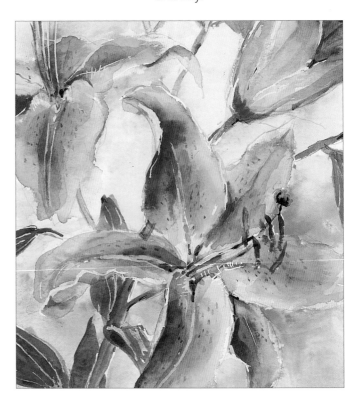

Page 1
Sunlit Garden Corner
12 x 16cm (30 x 40in)
*Adding sunlight and long shadows among the
garden plants gives atmosphere and drama
to everyday objects.*

Opposite
Memories of Summer
35 x 30cm (13¾ x 12in)
*Paintings of sunflowers are always dramatic, strong and vibrant,
especially if you add exciting colours in the background.*

Contents

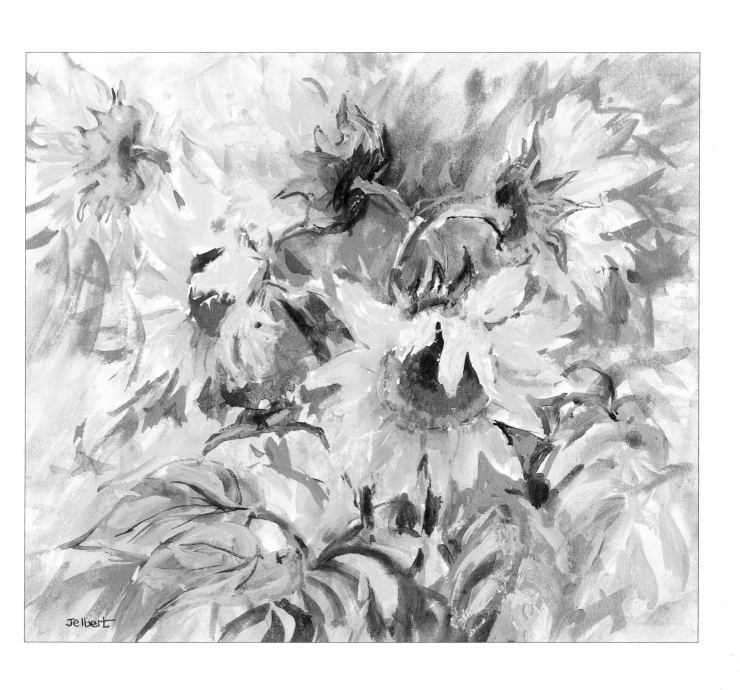

Introduction

Throughout the ages, flowers have challenged and inspired the artist. Their beauty can be dynamic or fragile, their colouring vibrant or delicate, and their translucent texture makes them irresistible to me. All of these qualities make them well-suited to being captured by acrylic paints, the most versatile of media.

Acrylics can be adapted to a wet into wet watercolour style, oil style, or a mixture of both – all in the same painting! The aim of this book is to guide and encourage you to try out several varieties of flowers in an exciting assortment of colour mixes and methods: the tantalising beauty of flowers can be captured in many different ways.

It is an excellent basic discipline to be able to draw these subjects freehand, but if you are nervous about your drawing skills, there is help close at hand! At the front of this book are five tracings that will give you the initial lines for each of the projects, plus an extra tracing of the picture opposite for you to try once you decide you would like the challenge.

I hope that you find painting flowers as enjoyable as so many painters do!

TRACING
1

Opposite
Loving the Cow Parsley
30 x 40cm (12 x 15¾in)

Insects, such as bees and butterflies, can add interest to any of your flower paintings.

4

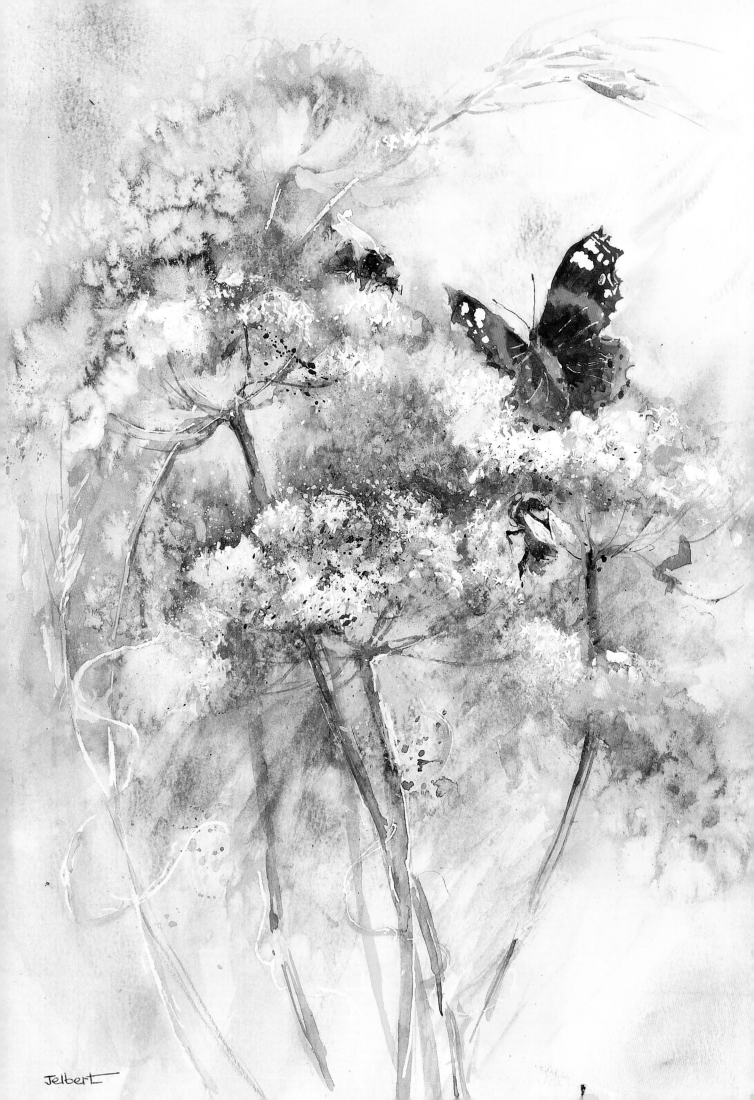

Jelbert

Materials

Paints

Buying the best quality paints is always the best policy. Students' quality paints do not have the vibrancy or covering power of artists' quality. You could try a starter set of artists' acrylics to begin with, as these often have a good range of colour.

Alternatively, buy a palette of tubes including the primary colours and a few useful extras. Here are my suggestions for a starting palette.

Cadmium yellow A gorgeous colour for adding a 'glow' to your flower paintings.

Dioxazine violet This is essential for deep colours in flowers and foliage.

Cadmium orange A lovely dramatic colour for mixing, and great for vibrancy when used on its own.

Cadmium red deep This is important for making deep reds, and again is useful for colourful petals when used neat.

Hooker's green A useful paint for foliage, this can be easily darkened or lightened without getting too muddy.

Titanium white This is useful for highlighting, or tinting the other colours as necessary.

French ultramarine Ideal for deepening shadows and adding into foliage colours.

Olive green A gentle but strong mid-green, excellent for foliage and good for mixing in with yellows and blues.

Permanent rose My 'must-have' colour for flower paintings, this adds an unusual hue and sparkle to red flowers.

Phthalo blue (green shade) This gives a kick to foliage colours and vibrancy to backgrounds.

Acrylic paints are available in tubes.

Paper and board

There are specially prepared papers for acrylics which have a variety of finishes similar to Not or rough watercolour papers, and even textures such as canvas.

These all help to enhance the versatility of your acrylics, so experiment until you find a surface that suits you well.

For the projects in this book, I use a pad of 300gsm (140lb) Not watercolour paper.

Brushes

There are many brushes I find perfect for acrylics and the variety of methods used. They provide a good choice if you are just starting out:

Detail brush A size 4 round sable is perfect for tiny details.

Small flat brush Like the larger brush, this 10mm (⅜in) flat allows for a diverse range of strokes depending on which part of it you use. I use this for smaller details.

Large flat brush Used for most of the initial work, this type of brush is very versatile, and I use a 25mm (1in) flat brush for most of the initial work in the projects.

Large mop brush This is used to wet large areas of paper for watercolour-style painting, and also for laying in large diluted washes.

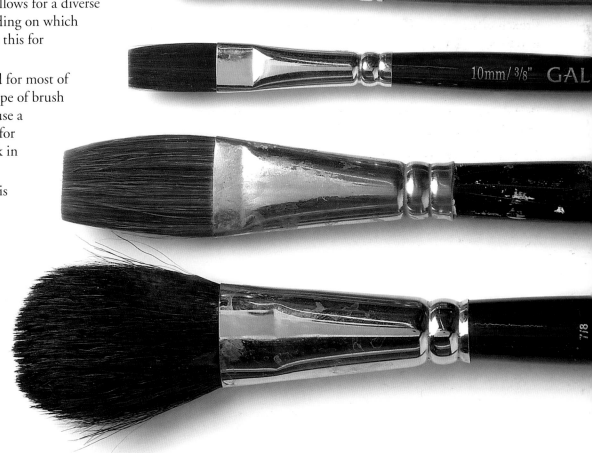

Other materials

Palette I use a stay-wet palette which keeps the paints workable and helps you with your mixing.

Easel Being able to secure your paper to a solid surface makes painting much easier, and helps to keep the paper flat.

Pencils A soft pencil, such as a 2B or 4B, is used to cover the lines on the back of your tracings.

Tissues As well as being used to dry your brushes, tissue can be used to dab excess paint.

Water pot Clean water is essential for many of the projects and for cleaning your brushes as you work.

Hairdryer This is used to speed up the drying and cutting the waiting time!

Masking fluid and **ruling/drawing pen** Masking fluid is ideal for keeping some of the paper clean while you work over it in a watercolour style, allowing you to add fine details to your painting. The ruling/drawing pen is ideal for applying the fluid.

Sponge A piece of natural sponge can be used to create a random effect that is perfect for leaves and other foliage.

Palette knife There are various plastic and metal palette knives available, so choose the one that suits you. I use a wedge-shaped medium-sized knife which is adaptable to my uses.

Masking tape This is used to secure the paper to the easel and keep it safely in place as you work.

Texture paste There are many varieties of texture paste, all useful for different surfaces. It is worth experimenting with as many as possible for solving textural problems.

Transferring the image

It could not be easier to pull out a tracing from the front of this book and transfer the image on to paper. You should be able to reuse each tracing several times if you want to create different versions of the scene.

1 Scribble on the reverse of the tracing with a 2B pencil.

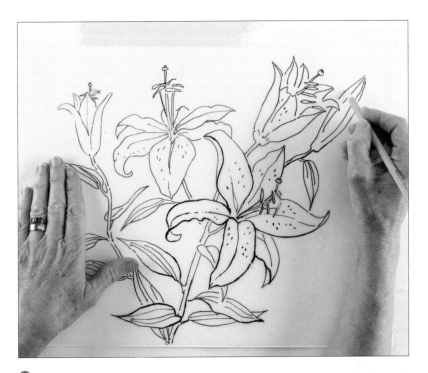

2 Turn the tracing right side up and tape the top edge down on a piece of watercolour paper using masking tape. Use a pencil to go over all the lines of the tracing. If you are right-handed, work from left to right so as not to smudge what you have already drawn, and vice versa if you are left-handed.

3 Lift up the tracing and you will see the drawing beginning to appear on the watercolour paper. Do not worry if it looks faint; if it is too strong the graphite can smudge during the painting process and look untidy.

Hollyhocks

I found this beautiful hollyhock scene near La Rochelle in France. The gentle sunlit door was in such contrast to the vibrant red-orange flowers that I just had to paint it!

TRACING
2

You will need

300gsm (140lb) Not paper, 30 x 40.5cm (12 x 16in)

Colours: cadmium yellow, titanium white, cadmium orange, cadmium red deep, French ultramarine, Hooker's green, cadmium red, cobalt blue, burnt sienna, yellow ochre, raw umber and dioxazine violet

Brushes: 25mm (1in) flat, 10mm (⅜in) flat, large mop brush, size 4 round

Masking tape and board

Masking fluid and ruling/drawing pen

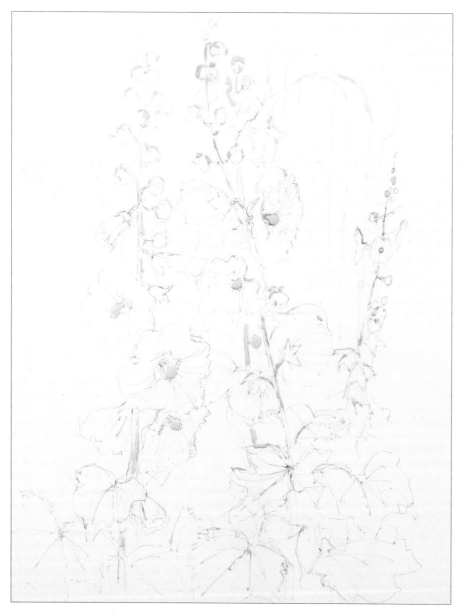

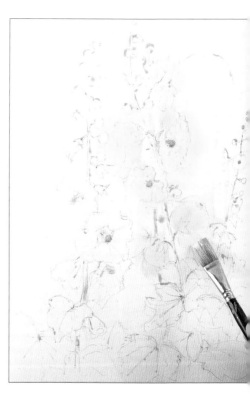

1 Transfer the scene on to watercolour paper as shown on page 9, then secure the board to the easel with masking tape. Use the ruling/drawing pen to apply masking fluid to the areas shown.

2 Using the mop brush, apply clean water across the whole piece, then drop in a dilute mix of cadmium yellow and titanium white to the central hollyhocks with the 25mm (1in) flat brush.

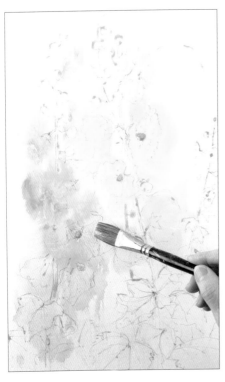

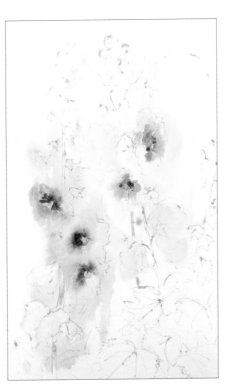

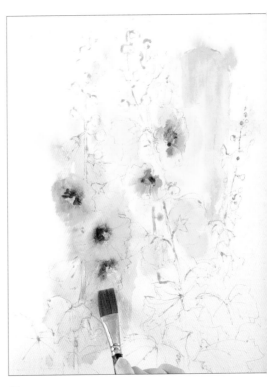

3 Working wet into wet, apply dilute cadmium orange to the left-most hollyhocks.

4 Switch to the 10mm (⅜in) flat and apply cadmium red deep with a touch of French ultramarine to the centres of the orange flowers, and a mix of cadmium red with a touch of cadmium yellow to the yellow flowers.

5 Still working wet into wet, apply dilute cadmium yellow to the door and orange flowers, using the 25mm (1in) flat brush.

6 Make a dilute mix of Hooker's green with cadmium yellow and paint the leaves in the foreground, varying the mix with French ultramarine and more cadmium yellow.

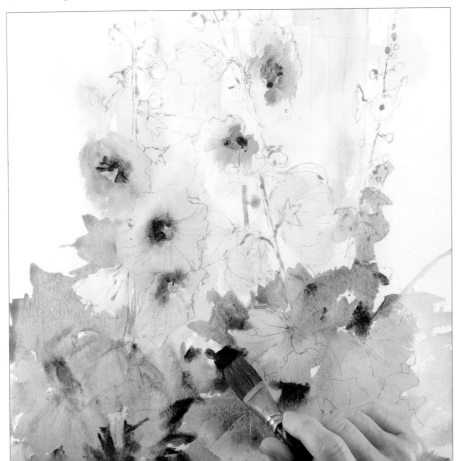

7 Add some touches of cadmium orange tinted with titanium white to the central flowers, and allow to dry.

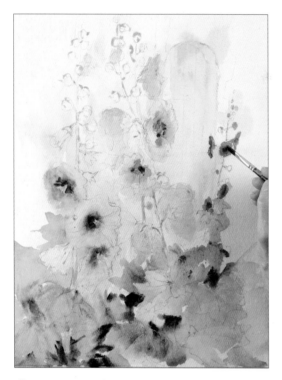

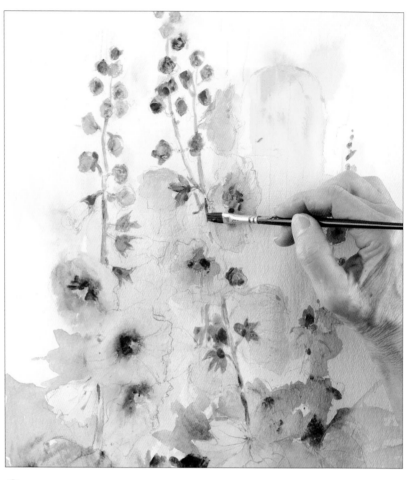

8 Switch to the 10mm (³⁄₈in) flat and paint the right-hand flowers with cadmium orange. Add shading to the centres with cadmium red deep.

9 Make a fairly dilute mix of Hooker's green and cadmium yellow, and use it to paint the buds and calyxes (bases of the flowers) as shown. Vary the mix to introduce natural highlighting and shading. Paint the stems with the same mixes.

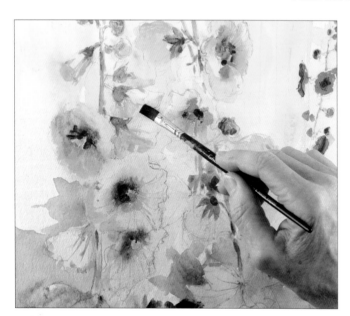

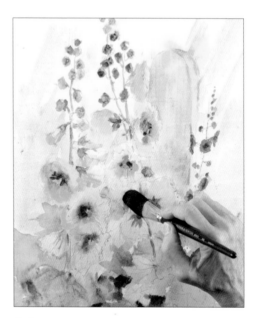

10 Add some veins and shading to the hollyhocks on the left with a mix of cadmium orange and touches of titanium white and cadmium red.

11 Wet the door and background with clean water and add some shadows at the back using a mix of cobalt blue, titanium white and a touch of burnt sienna. Apply the mix with the mop brush.

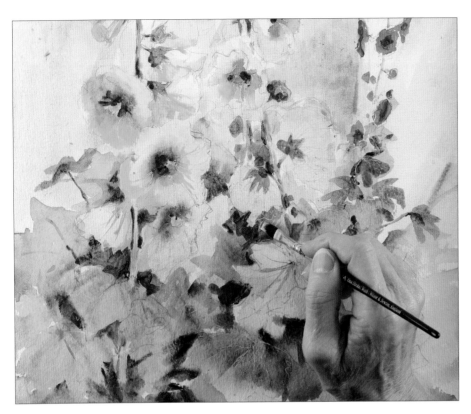

12 Shade and detail the leaves with a fairly strong mix of Hooker's green, using the 10mm (⅜in) flat.

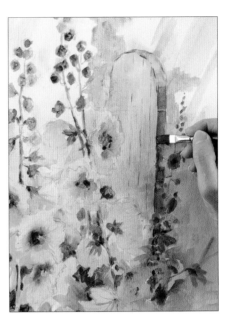

13 Re-wet the recess of the door and drop in a mix of raw umber and yellow ochre. Dilute this mix and use it to hint at exposed brickwork around the door. Once dry, use the edge of the brush to add details to the door with an undiluted mix of the same colours.

14 Intensify the blue shadow at the back, glazing another dilute layer of cobalt blue and titanium white to make the left-hand hollyhocks sing against the background.

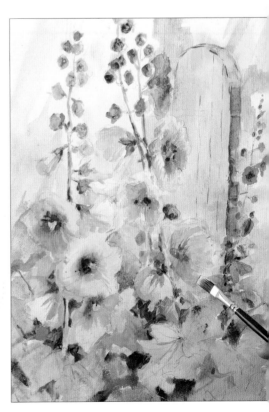

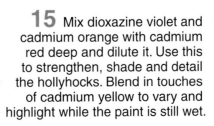

15 Mix dioxazine violet and cadmium orange with cadmium red deep and dilute it. Use this to strengthen, shade and detail the hollyhocks. Blend in touches of cadmium yellow to vary and highlight while the paint is still wet.

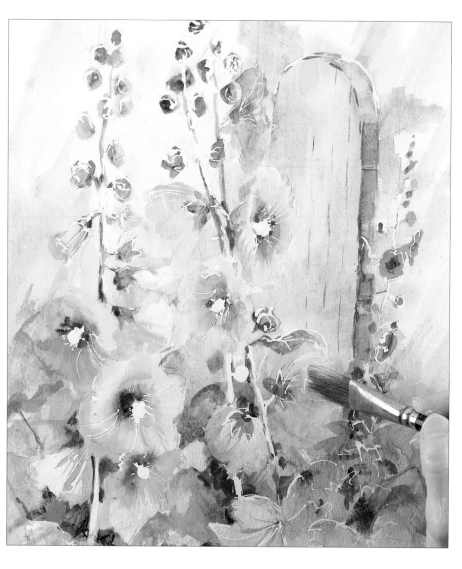

16 Allow all the paint to dry completely, then use a clean finger to remove the masking fluid with a gentle rubbing action.

17 Glaze the central flowers with a dilute mix of cadmium yellow and titanium white, using the 25mm (1in) flat.

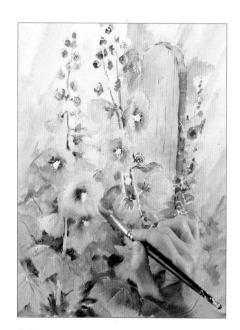

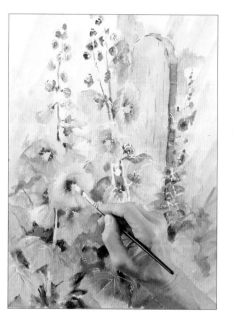

18 Add cadmium orange to the mix and glaze the left-hand hollyhocks.

19 Fill in the centres of the flowers after adding cadmium yellow to the mix. Use the 10mm (⅜in) flat.

20 Highlight and knock back the right-hand flowers with a mix of titanium white and cadmium red deep.

21 Make an extremely diluted light green mix of Hooker's green and cadmium yellow and use it to wash over the stems, buds and veins of the leaves.

22 Use the size 4 round brush to add cadmium red deep details to the hollyhock flowers on the left. Deepen the shading by adding dioxazine violet.

23 Use a mix of cadmium orange and titanium white to vary the intensity of the central hollyhocks. Vary the tone with burnt sienna for shading.

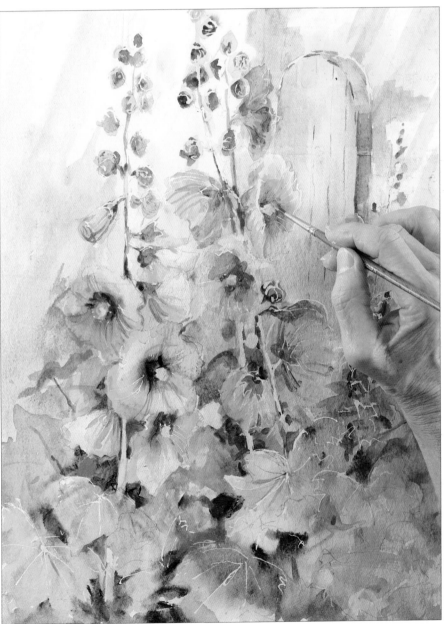

15

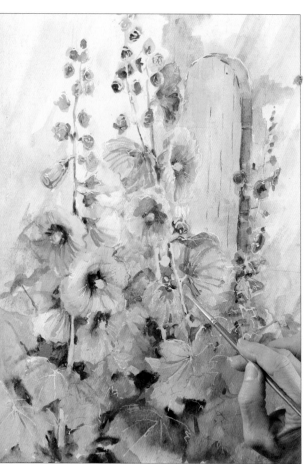

24 Reshape the flowers if necessary using the relevant background mixes.

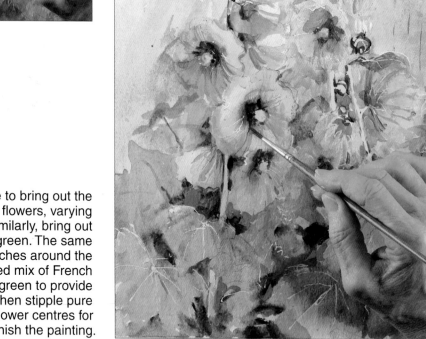

25 Use cadmium orange to bring out the contrast on the left-hand flowers, varying them with burnt sienna. Similarly, bring out the buds with Hooker's green. The same colour can be added in touches around the flower centres. Use a diluted mix of French ultramarine and Hooker's green to provide the deepest shades, then stipple pure titanium white on to the flower centres for the brightest highlights to finish the painting.

Opposite

The finished painting.

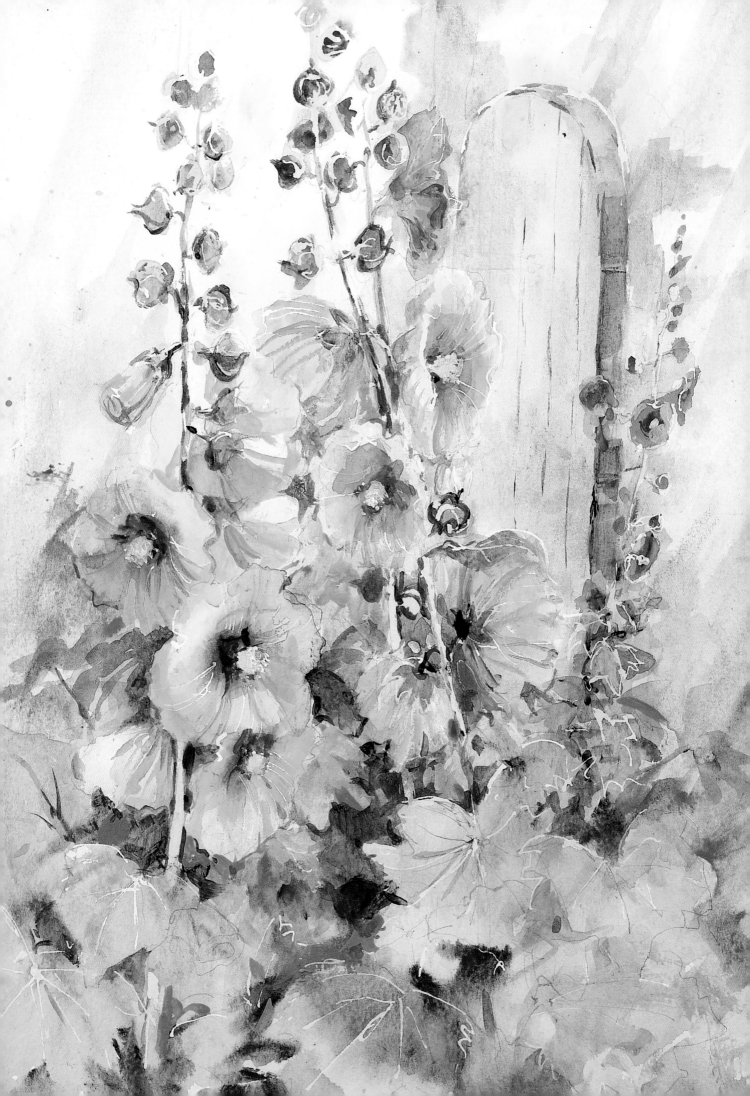

Poppies and Daisies

I discovered this breathtaking swathe of poppies and daisies as I was cycling in the North Hampshire countryside. One of the local farmers won an award for growing the array of wild flowers around his whole farm of cornfields. It attracted all the local artists like bees to a honeypot!

You will need

300gsm (140lb) Not paper, 40.5 x 30cm (16 x 12in)

Colours: perinone orange, cadmium yellow, cadmium red, burnt sienna, yellow ochre, cobalt blue, titanium white, olive green, Hooker's green, French ultramarine, phthalo blue (green shade), permanent rose and dioxazine violet

Brushes: 25mm (1in) flat, 10mm (⅜in) flat, size 4 round

Masking tape and board

TRACING
3

1 Transfer the scene on to watercolour paper as shown on page 9, then secure the paper to the board with masking tape.

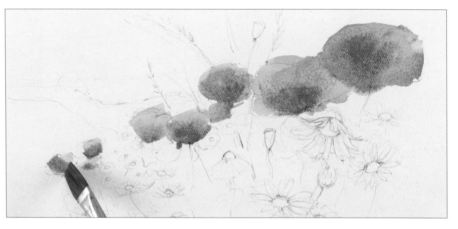

2 Mix perinone orange with cadmium yellow and cadmium red. Use the 25mm (1in) flat brush to paint the poppies, using bold strokes and a fairly dilute wash. Drop in cadmium red wet into wet to give the feeling of the sun catching them.

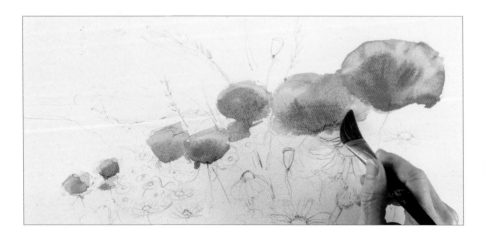

3 Clean and dry your brush, then use it to lift out some highlights by drawing it over the damp paint. Let the poppies dry.

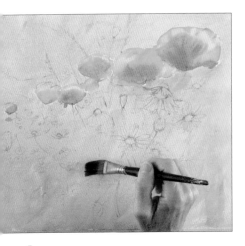

4 Make a mix of burnt sienna, yellow ochre, titanium white and perinone orange, then lay it over the whole picture. Allow to dry. This acts as an underpainting that will give contrast and unity to the finished painting.

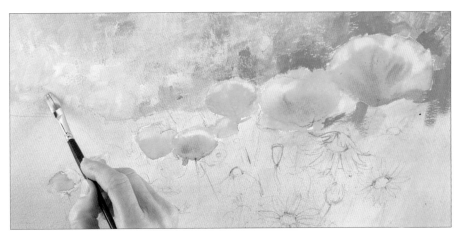

5 Make a fairly strong mix of cobalt blue and titanium white, and use the 10mm (⅜in) flat brush to lay in the sky. Vary the proportions of the paints, using the darker blues nearer the poppies to make them advance, and using lighter blues the further left you go. Leave some of the underpainting showing through.

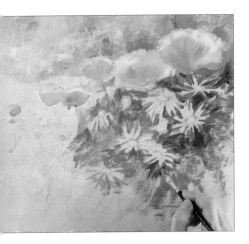

6 Mix a mid-green of olive green and cadmium yellow and drop it in around the foliage in the foreground. Vary the hue with Hooker's green and French ultramarine, and add more cadmium yellow to the frontmost foliage.

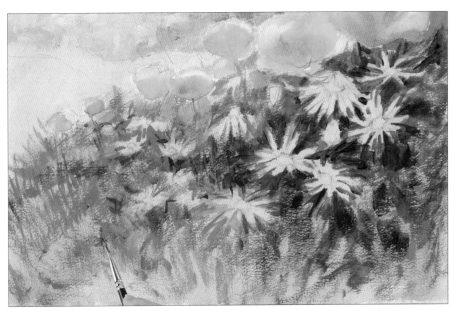

7 Continue working the greens across the whole area and mix in some of the sky blue mix towards the left and back.

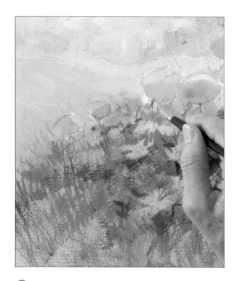

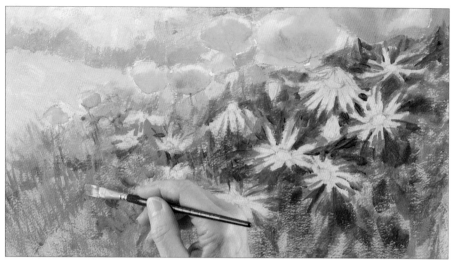

8 Still using the 10mm (⅜in) flat brush, mix cadmium yellow with titanium white and a touch of olive green. Use this to block in the distant field on the left.

9 Add more titanium white and phthalo blue (green shade) to the mix and scrub in the hedge on the horizon with brisk vertical strokes. Use the same mix to add a few grasses to the foreground on the left.

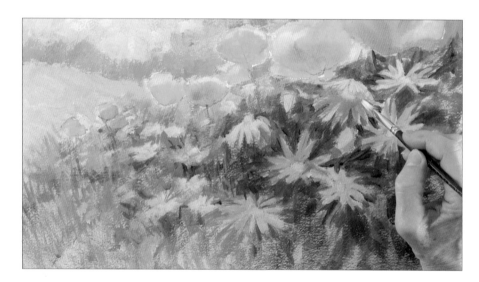

10 Add a touch of French ultramarine to titanium white, and pick out the petals of the daisies.

Tip

If you have covered your pencil lines, refer to the tracing to help pick out the main flowers.

11 Add more French ultramarine to the mix, and use it to paint in a few more daisies in the shade.

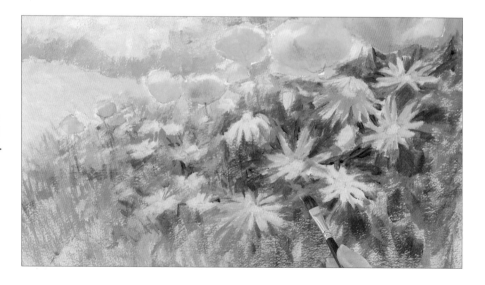

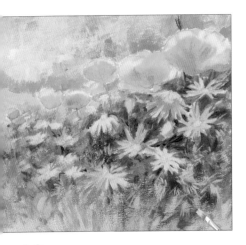

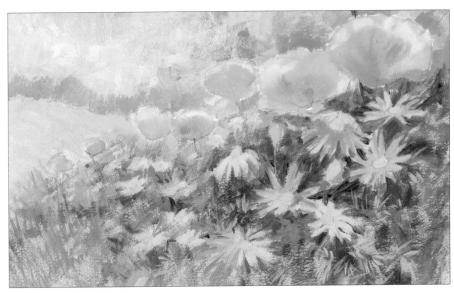

12 Paint in the poppy buds with a mix of cadmium yellow, Hooker's green and titanium white. Use the same mix for the daisy leaves and stems.

13 Use pure cadmium yellow to fill in the daisy centres.

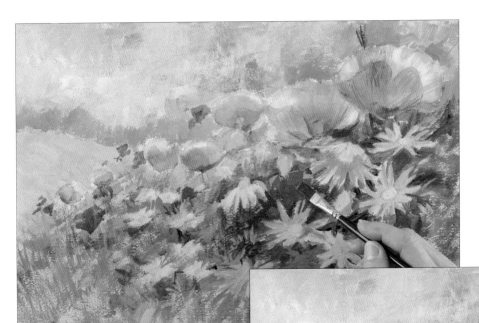

14 Shade and shape the poppies with a glaze of cadmium red and permanent rose. You can add additional background poppies with this mix.

15 After adding titanium white and a little cadmium yellow to the mix, highlight and detail some of the poppies.

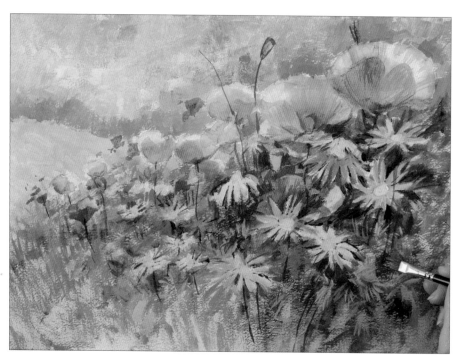

16 Mix a dark green from olive green, French ultramarine and Hooker's green. Use this to deepen the tone of the foliage on the right and to pick out the petals on the daisies. The colour can also be used to define the buds and stems. Use the flat of the brush to suggest the stalks.

17 Paint in the wild corn with a mix of yellow ochre and burnt sienna. The same colour should be used to paint the maturing grasses in the foreground. These can be highlighted by adding perinone orange to the mix.

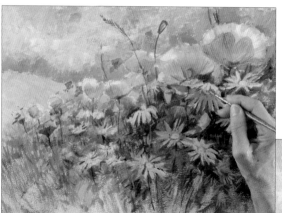

18 Soften the background with touches of the sky mix, then switch to the size 4 and use a mix of burnt sienna and yellow ochre to detail the daisy centres.

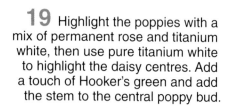

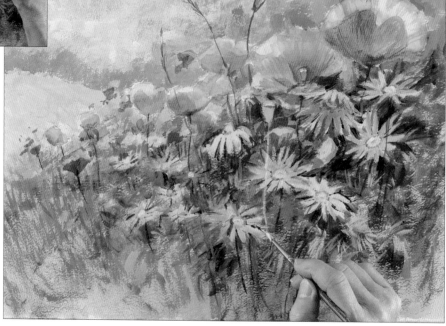

19 Highlight the poppies with a mix of permanent rose and titanium white, then use pure titanium white to highlight the daisy centres. Add a touch of Hooker's green and add the stem to the central poppy bud.

20 Use the same light green mix to highlight the stems and buds, then add olive green to pick out further details.

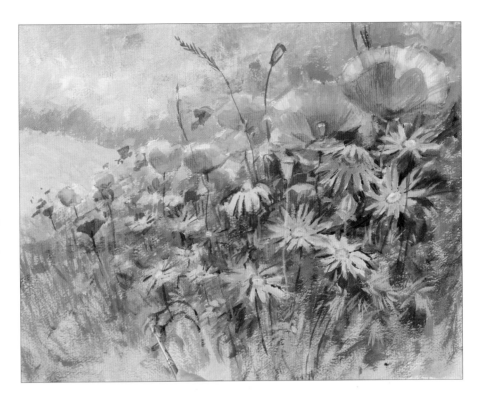

21 Add touches of a dioxazine violet and Hooker's green mix to add depth and a dynamic feel to the painting. Paint final highlights of titanium white with a touch of cadmium yellow on the daisies to heighten the contrast and give impact.

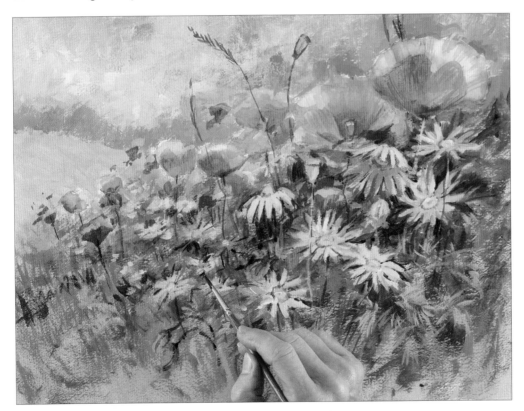

Overleaf

The finished painting.

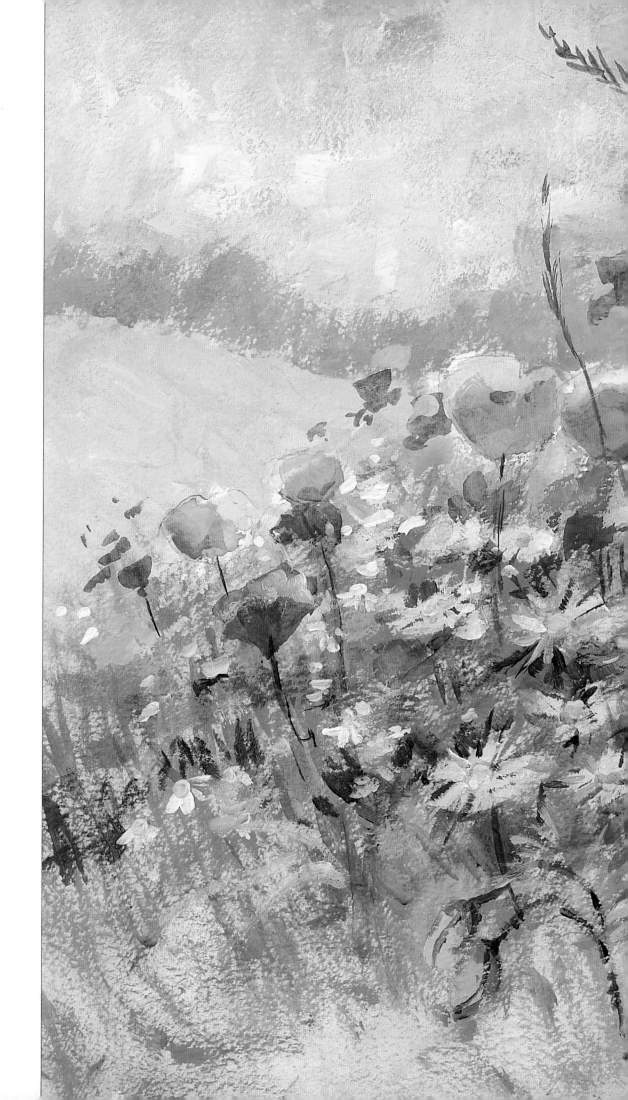

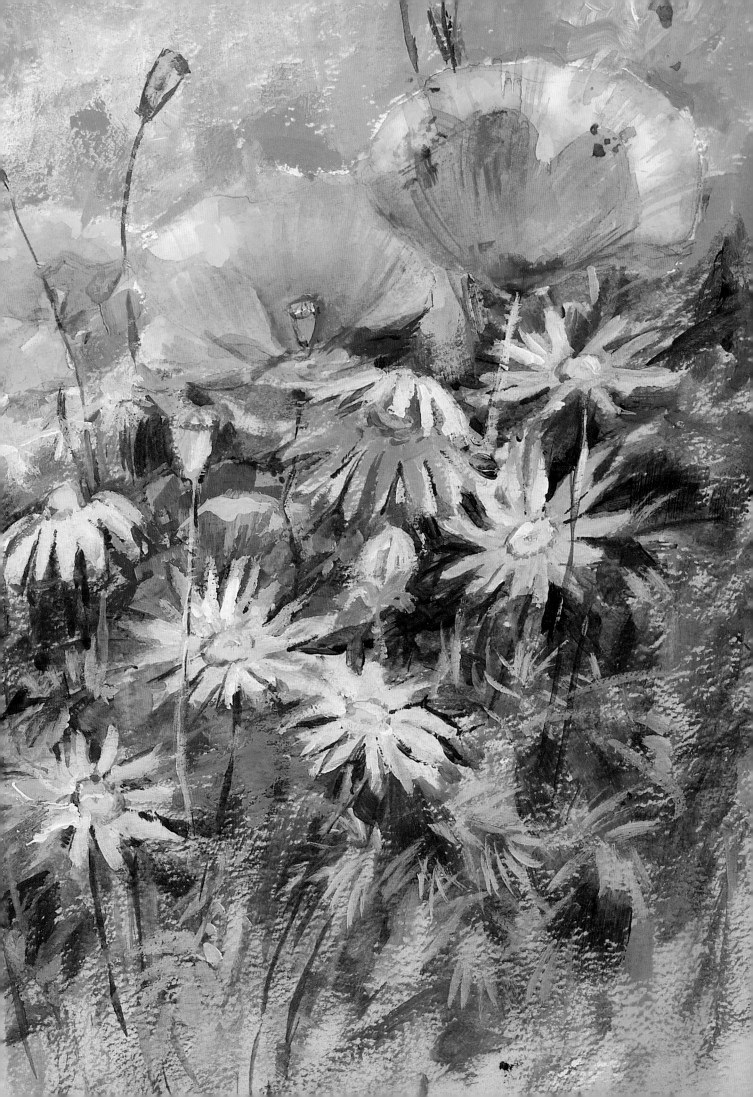

Windowbox

There is some skill and observation in capturing massed flowers and foliage, and in this Venetian scene I have included several beautifully textured and contrasting plants. Their variety and colours are the ingredients for this magical and delightful windowbox and balcony.

TRACING

You will need

300gsm (140lb) Not paper, 40.5 x 30cm (16 x 12in)

Colours: neutral grey, titanium white, phthalo blue (green shade), burnt sienna, yellow ochre, dioxazine violet, Hooker's green dark, French ultramarine, cadmium red, cadmium orange and cadmium yellow.

Brushes: 10mm (⅜in) flat, sword brush

Palette knife

Masking tape and board

Masking fluid and ruling/ drawing pen

Sponge

Fine texture gel

1 Transfer the scene on to watercolour paper as shown on page 9, then secure the paper to the board with masking tape. Use the ruling/drawing pen to apply masking fluid to the areas shown.

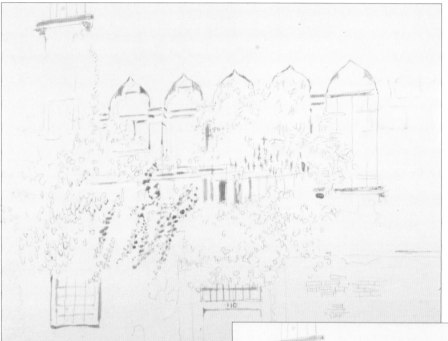

2 Use a sponge to apply a little masking fluid around the bush in front of the window.

26

3 Apply fine texture gel with a small palette knife across the broken brickwork at the bottom right of the picture.

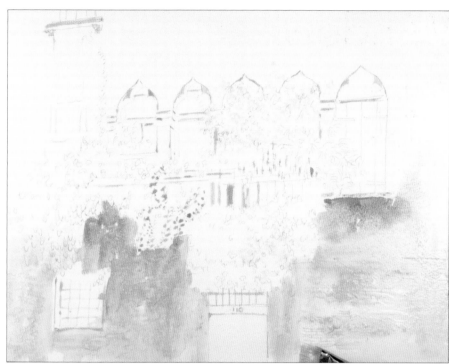

4 Use the 10mm (⅜in) flat brush to wet the walls with clean water. Drop in neutral grey, titanium white and phthalo blue (green shade) in a variegated wash, allowing each colour to bleed into the others.

5 While the paper is still wet, introduce burnt sienna and yellow ochre into the wash at the upper half of the picture and add touches of dioxazine violet below the window box.

Note

The sword brush is a specially designed shortened sword-liner with an inbuilt rigger, which I use for a wide range of excellent and essential effects without having to use lots of different brushes.

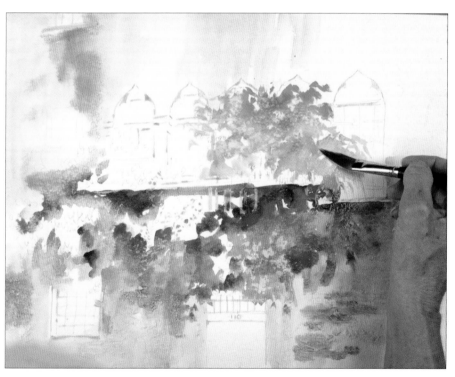

6 Switch to the sword brush and introduce a mix of Hooker's green dark and cadmium yellow across the foliage in the lower centre using a dabbing motion. Add a little of the green mix to phthalo blue (green shade) and paint the foliage in front of the windows.

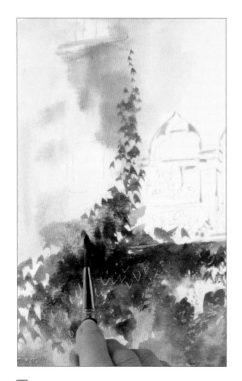

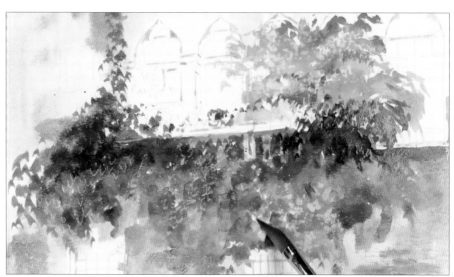

7 Add French ultramarine to the blue-green mix and use a gentle stabbing motion with the tip of the sword brush to paint the ivy on the left.

8 Add French ultramarine and phthalo blue (green shade) touches to vary the foliage in front of the windows while they are still damp. Add some cadmium red geraniums in the windowbox and some cadmium orange geraniums above the door.

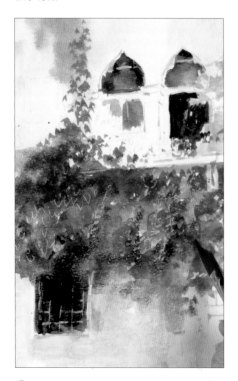

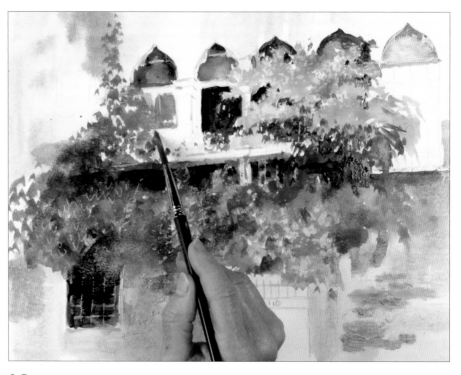

9 Introduce some darks in the windows with a mix of dioxazine violet and French ultramarine. Add touches of Hooker's green dark and phthalo blue (green shade) to vary the tone. Work carefully, but not fussily. Draw the colour up into the ivy from the bottom window.

10 Use the same darks to reinforce the window box and add burnt sienna for the windows behind the foliage. Add the original green mix of Hooker's green dark and cadmium yellow on the left as shown.

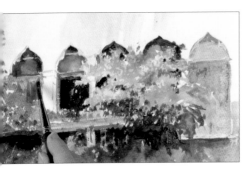

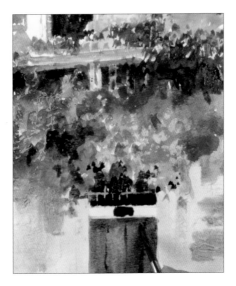

11 Paint the shutter on the right and at the top left with yellow ochre. Add touches of burnt sienna to simulate peeling paint. The same colour can be used for the window surrounds.

12 Paint the area above the door with strong darks of dioxazine violet and French ultramarine. Add touches of yellow ochre and burnt sienna for the door itself. Use the tip of the sword brush to define the planking of the door.

13 Use the various green mixes to refine the foliage and allow to dry. Use a clean finger to rub away all of the masking fluid (see inset).

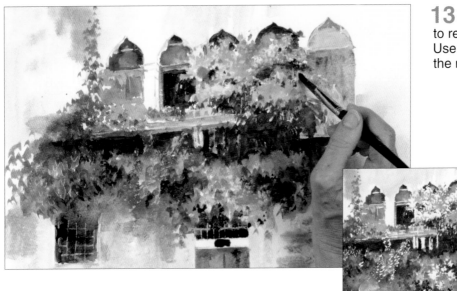

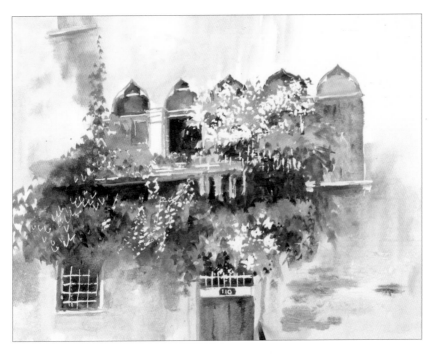

14 Mix phthalo blue (green shade) with a touch of burnt sienna for a cool grey and use this to paint shading in the windows. Add a touch of titanium white to increase the texture and show the thickness of the walls. Use the same mix with a touch of dioxazine violet to detail the rest of the architecture.

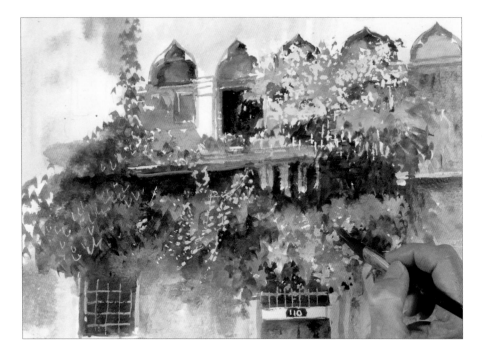

15 Use dilute washes of the appropriate green mixes to knock back the stark white of the foliage revealed by the removal of the masking fluid.

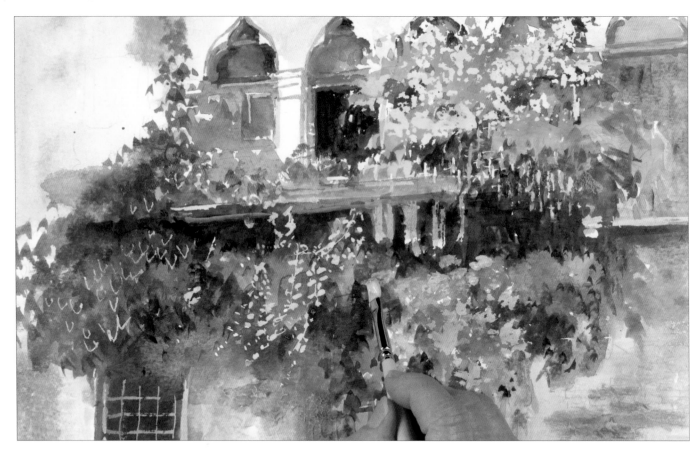

16 Mix cadmium orange with cadmium yellow and titanium white and paint the fuchsias on the top right with short downward strokes of the sword brush. Use the same fairly thick mix to highlight the geraniums above the door and by the windows using the 10mm (⅜in) flat brush.

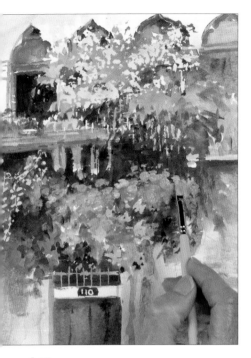

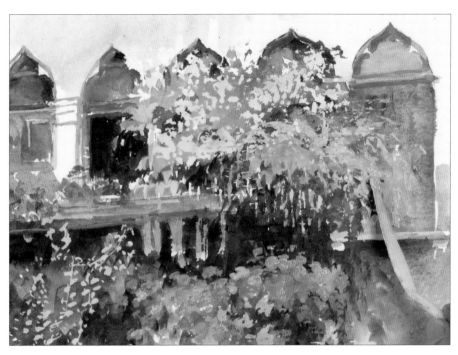

17 Make a very thick mix of phthalo blue (green shade) and cadmium yellow, and use it to dot on to the foliage above the door.

18 Use the palette knife to apply a very thick mix of phthalo blue (green shade), titanium white and cadmium yellow to the fern on the far right.

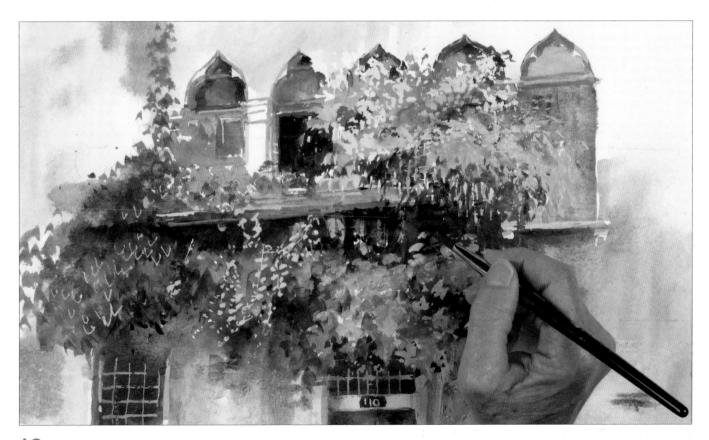

19 Add any final details, such as strengthening the shadows beneath the fern.

Overleaf

The finished painting.

Stargazer Lilies

These dazzling, eyecatching flowerheads would grace any painting. Care should be given to include closed as well as half-opened buds, as these are just as dramatic as the vibrant petals.

Glimpses of phthalo blue (green shade) through the background add an extra little lift to the whole picture.

You will need

300gsm (140lb) Not paper, 40.5 x 30cm (16 x 12in)

Colours: cadmium yellow, cadmium orange, cadmium red, permanent rose, Hooker's green, phthalo blue (green shade), French ultramarine, dioxazine violet, titanium white and perinone orange

Brushes: 25mm (1in) flat, 10mm (⅜in) flat, size 4 round

Masking tape and board

Masking fluid and ruling/drawing pen

TRACING

5

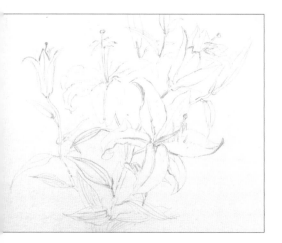

1 Transfer the scene on to watercolour paper as shown on page 9, then secure the paper to the board with masking tape. Use the ruling/drawing pen to apply masking fluid as shown.

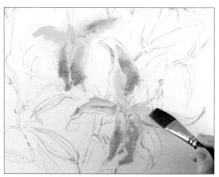

2 Use the 25mm (1in) flat brush to wet the petals of the main flowers with clean water. Drop in dilute cadmium yellow and draw it along the petals. Working wet into wet, drop in dilute cadmium orange.

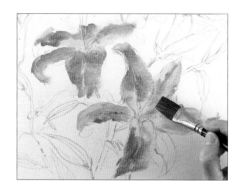

3 Still working wet into wet, make a mix of cadmium red and permanent rose and drop it into the flowers.

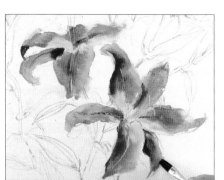

4 Switch to the 10mm (⅜in) brush and drop cadmium red and dioxazine violet into the wet paint.

5 Allow to dry, then paint the two opening flowers in the same way, using less yellow and more violet in the mixes.

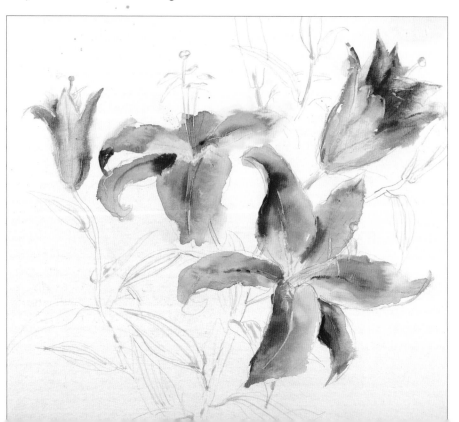

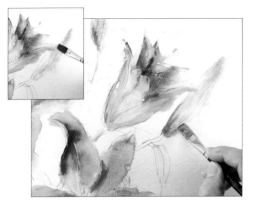

6 Wet the closed flowers with clean water, then drop in a little dilute permanent rose (see inset). Working wet into wet, add a green mix of Hooker's green with phthalo blue (green shade) and cadmium yellow. Use the same mix for the buds.

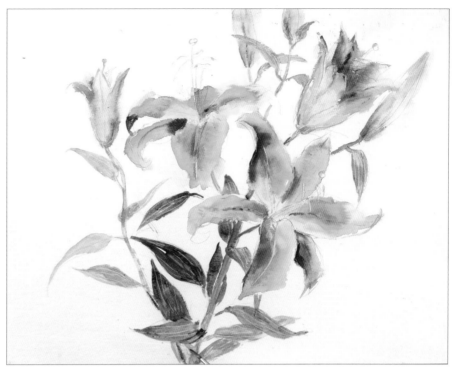

7 Make a deep blue-green from French ultramarine and Hooker's green and carefully paint in the leaves. Add cadmium yellow to vary the colour. Use long even strokes to bring out the texture of the leaves and stems, and dilute the mix for the background foliage.

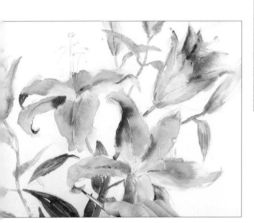

8 Detail the parts of the petals where they curl into the shade, using dioxazine violet with permanent rose, applying the paint with the size 4 brush.

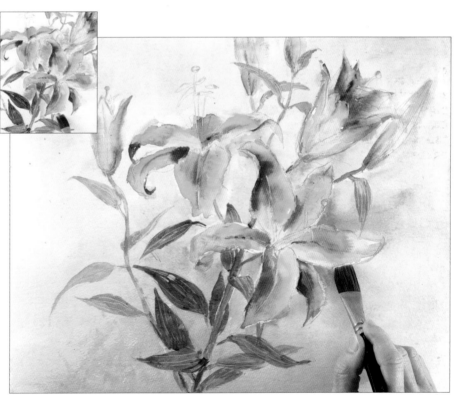

9 Use the 25mm (1in) flat brush to lay in clean water all over the white areas. Drop in dilute phthalo blue (green shade) around the flowers and centre as shown in the inset. Working wet into wet, add an extremely dilute mix of cobalt blue and titanium white to the edges, blending it into the phthalo blue (green shade). Work quickly but carefully to avoid harsh lines and backruns.

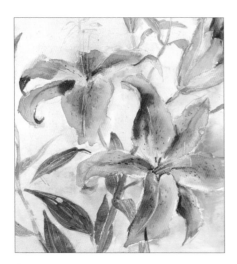

10 Line the veins and add the characteristic dots on the petals of the main flowers using the size 4 brush with a mix of cadmium red and dioxazine violet.

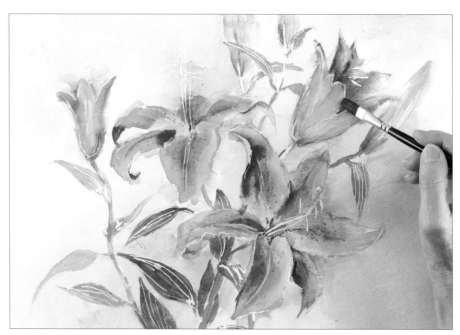

11 Allow the painting to dry completely, then use a clean finger to remove the masking fluid. Switch to the 10mm (⅜in) brush and use dilute perinone orange to wash over the petals of the lowest flower. Wash over the other open flower with cadmium yellow, and glaze the remaining flowers with cadmium red.

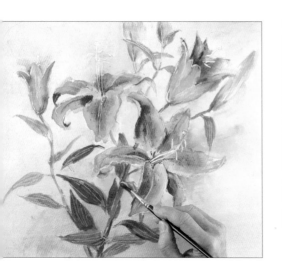

12 Mix Hooker's green with French ultramarine and dilute it. Use the mix to knock back all of the leaves and stems, adding titanium white and cadmium yellow to vary the colour.

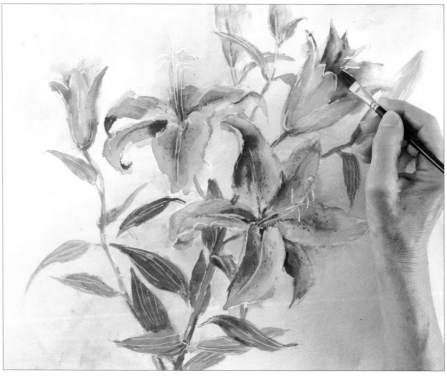

13 Use the same mix to shade the very centres of the open flowers. Blend cadmium yellow into the green in the centres and draw it up along the stamens of all the flowers.

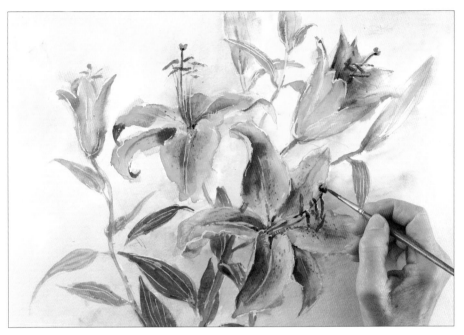

14 Use the size 4 brush to work in small areas of dioxazine violet over the petals, particularly in the centres. Use burnt sienna to paint in the anthers at the ends of the stamens, and shade them by adding dioxazine violet wet into wet.

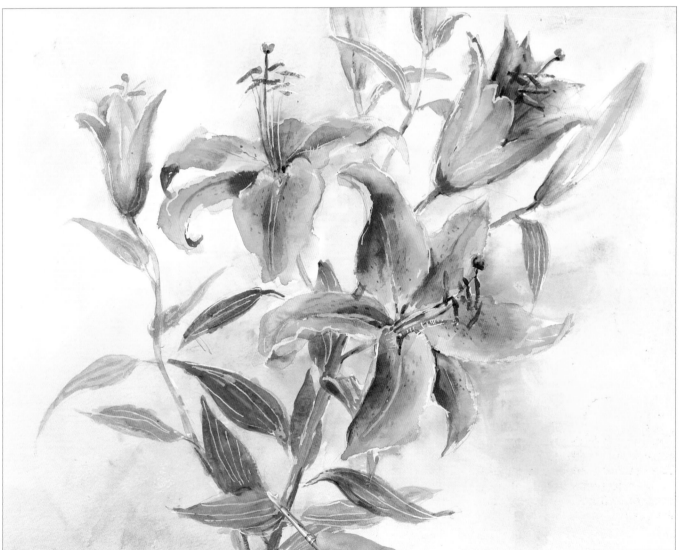

15 The painting is nearly complete, so make any tweaks you feel are necessary. Here I decided that some deep shading (made with dioxazine violet) would add to the detail.

Overleaf

The finished painting.

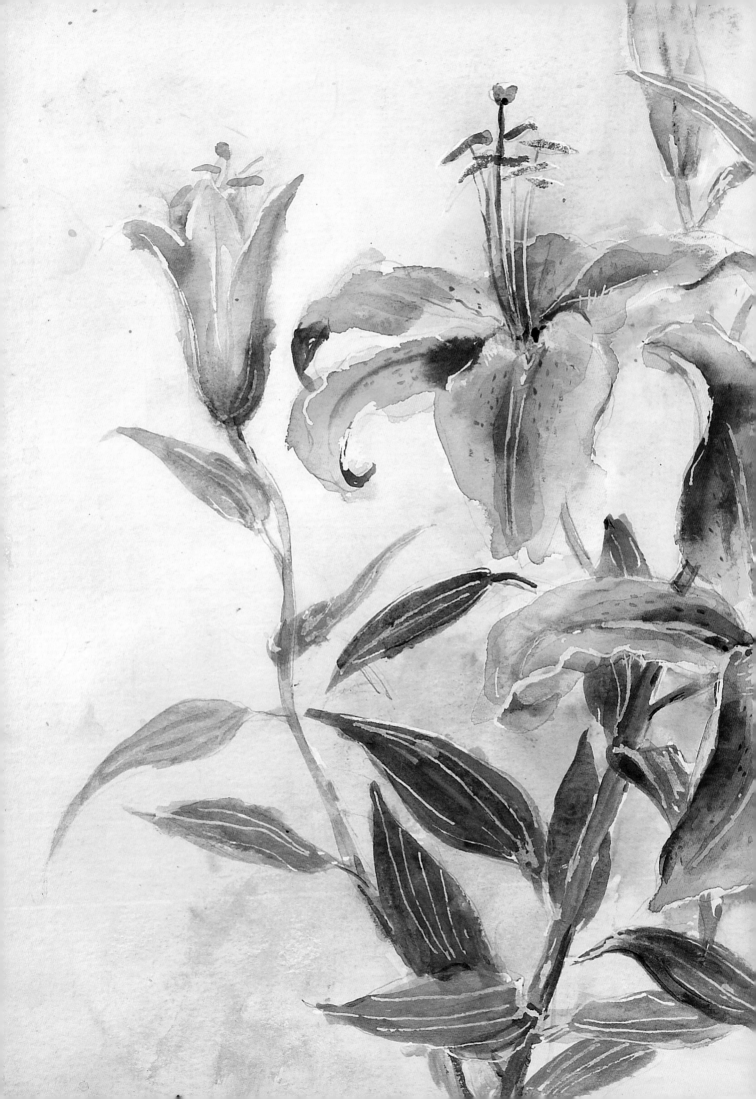

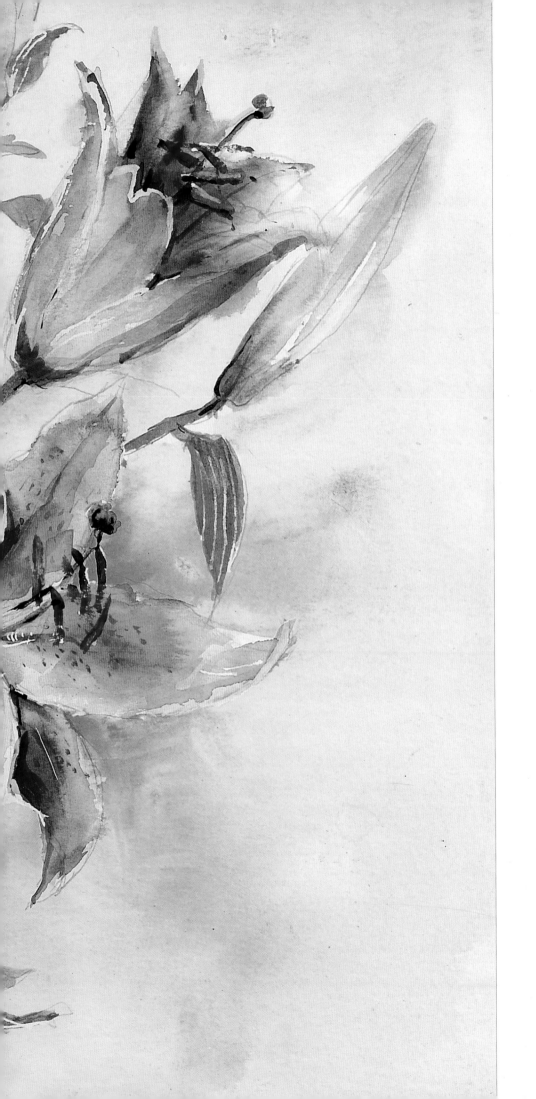

Foxgloves

I just adore these spires of pink bell shapes, colourfully jutting up from hedgerows and beneath the trees, adding patches of delightful contrasts amidst all the greens of summertime.

TRACING

6

1 Transfer the scene on to watercolour paper as shown on page 9, then secure the paper to the board with masking tape. Use the ruling/drawing pen to apply masking fluid to the areas shown.

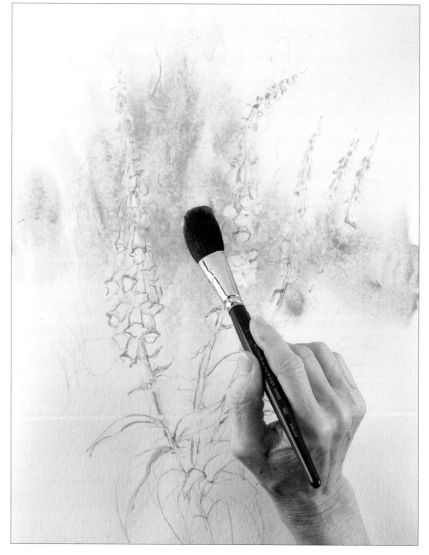

2 Prepare the following mixes: light blue-green, made from Hooker's green, cadmium yellow, titanium white and phthalo blue (green shade); dark green, made from French ultramarine and olive green; a mid-green made of a combination of the other green mixes; a sky blue made of titanium white and phthalo blue (green shade); and a pink made of titanium white and permanent rose. Wet the whole paper with clean water using the mop brush, then drop in the light blue-green around the middle as shown.

3 Still using the mop brush, drop in the dark green mix wet into wet to suggest the tree in the background.

4 Use a stronger mix of the blue-green to suggest the distant tree and hedge at the back.

5 Use the 10mm (⅜in) flat brush to drop in the sky mix on the top left and right.

6 Add cadmium yellow to the sky mix and use it to place in the distant field.

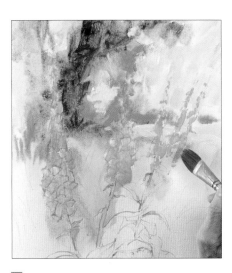

7 Drop in the pink mix over the foxgloves using the 25mm (1in) flat brush.

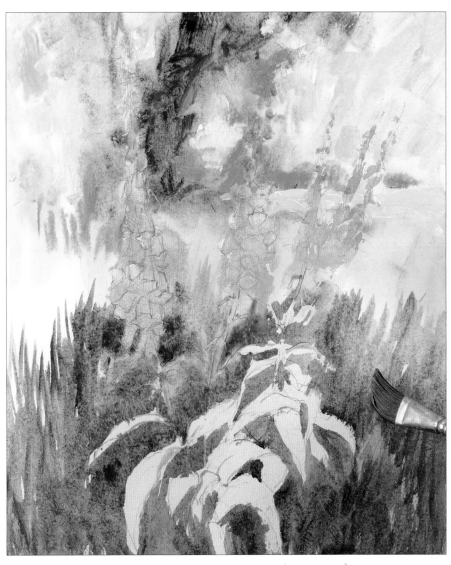

8 Add some extra French ultramarine to the dark green mix. Apply a dilute wash to the foreground, painting around the leaves with vertical strokes.

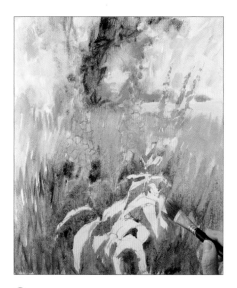

9 Fill in the middle ground with vertical strokes of the blue-green mix. Add cadmium yellow to the mix and vary the foreground and middle ground grasses. Allow to dry.

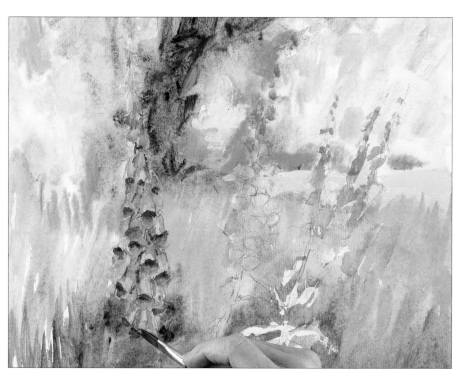

10 Add dioxazine violet to the pink mix and use the 10mm (⅜in) flat brush to fill in the shaded insides of the foxgloves on the left-hand side. While the paint is wet, soften the lower part of each by drawing out and softening the colour with a clean, damp brush. Add the shading between each flower with dilute permanent rose.

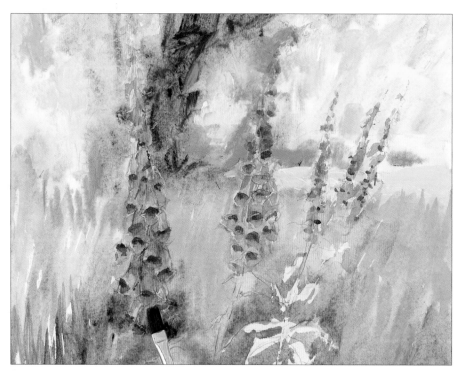

11 Repeat on the other foxgloves, then add a little cadmium orange to the foxgloves in the foreground.

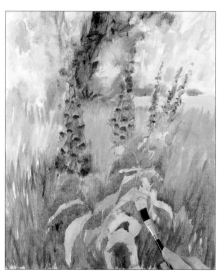

12 Use a very dilute wash of the blue-green mix to paint in the foreground leaves.

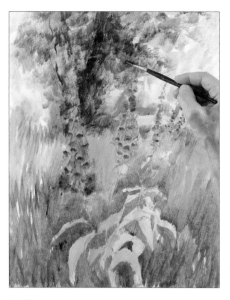

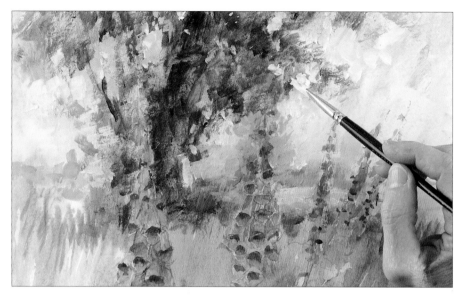

13 Use the mid-green with a fairly dry brush to add texture to the background foliage and grasses. Add the deepest shades with the dark green mix.

14 Use a strong mix of the sky blue to shape the background tree.

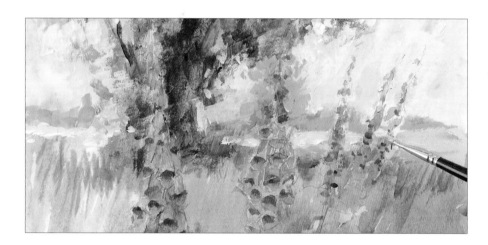

15 Reinstate the field with the earlier mix of cadmium yellow, titanium white and phthalo blue (green shade), and extend it to the left.

16 Add a touch of the sky blue mix to cadmium yellow, and use a sponge to lightly dab the background tree to add highlights.

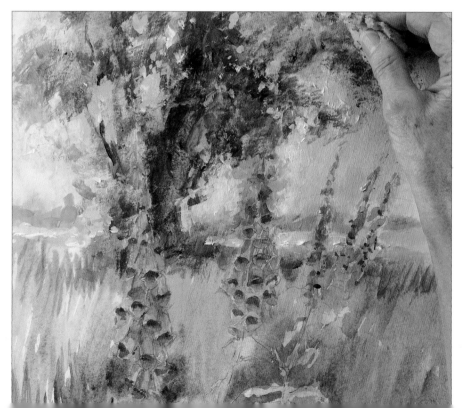

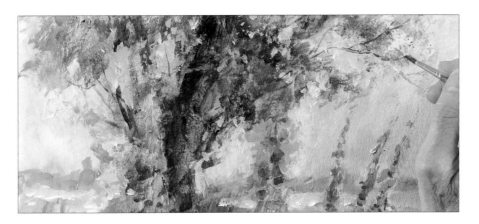

17 Switch to the size 4 brush and use the dark green mix to define the branches in the foliage of the background tree.

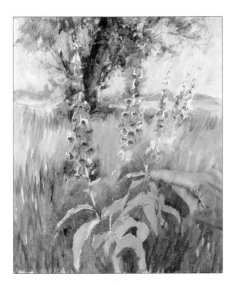

18 Allow the painting to dry completely, then use a clean finger to rub away all of the masking fluid.

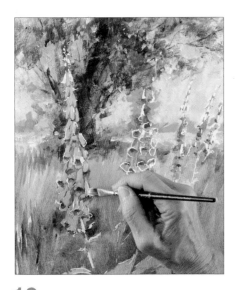

19 Mix titanium white with permanent rose and use the 10mm (⅜in) flat brush to highlight the foreground foxgloves.

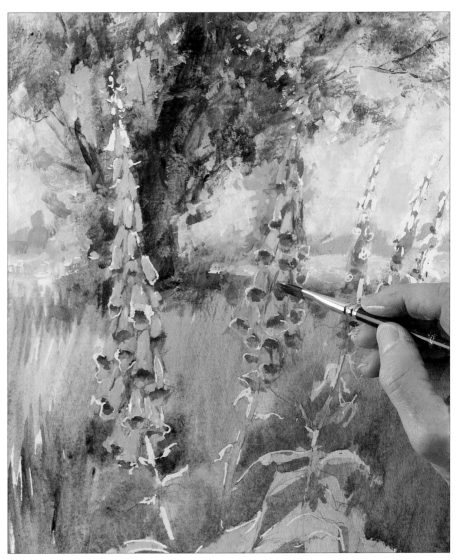

20 Add a touch of cadmium orange to the mix and highlight the foxgloves in the centre. Shape the central foxgloves with a mix of permanent rose, dioxazine violet and a touch of titanium white.

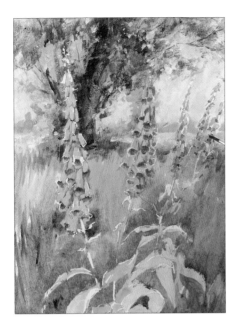

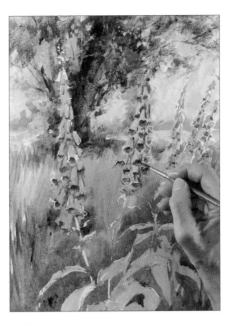

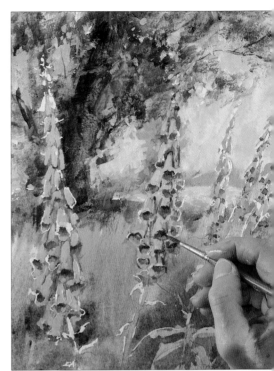

21 Highlight the right-hand foxgloves with the same mix as the left-hand foreground foxglove. Add permanent rose to vary the shading.

22 Switch to the size 4 brush to add the light pink highlights and dioxazine violet and permanent rose shading to the central foxgloves.

23 Glaze the insides of the foxgloves with the light pink mix, then add dots with the dioxazine violet and permanent rose mix.

24 Use the dark green mix (French ultramarine and olive green) to paint the stems. Highlight them with mid-green.

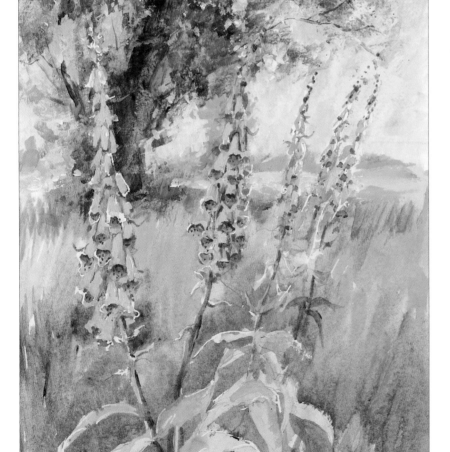

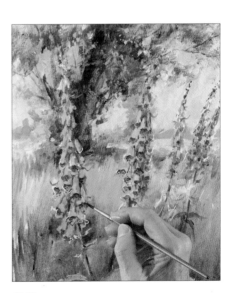

25 Use dioxazine violet to knock-back the right-hand foxgloves, and the same colour to shade the left-hand foxgloves. Vary the tone by adding a little French ultramarine wet into wet.

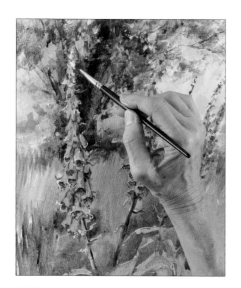

26 Use dilute French ultramarine to knock back the tree behind the top of the left-hand foxglove, then add topknots with a mix of titanium white and cadmium yellow using the 10mm (⅜in) flat brush.

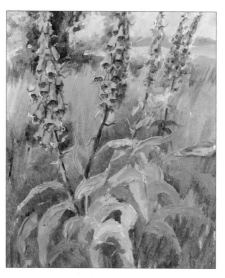

27 Switch to the palette knife and make a mix of phthalo blue (green shade), cadmium yellow and titanium white with a touch of Hooker's green. Apply it to the foxglove leaves. Vary the hue by overlaying pure phthalo blue (green shade).

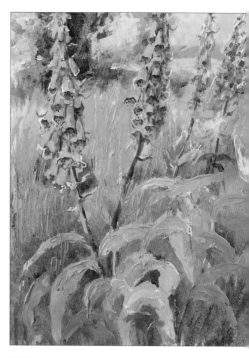

28 Use the edge of the palette knife to apply the mix to the grasses in vertical stripes. Drag the tip of the knife back down through the thick paint to create vertical texture.

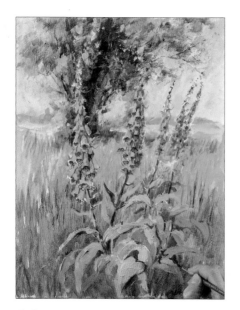

29 Switch to the size 4 brush and use the dark green mix to shade the leaves. Highlight with a titanium white, cadmium yellow, Hooker's green and phthalo blue (green shade) mix.

30 Make a mix of permanent rose and titanium white, and stipple in the suggestion of more foxgloves in the background. Shade them with pure permanent rose to finish the painting.

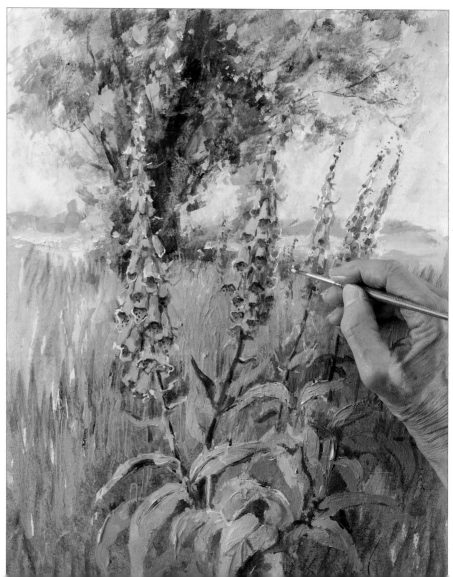

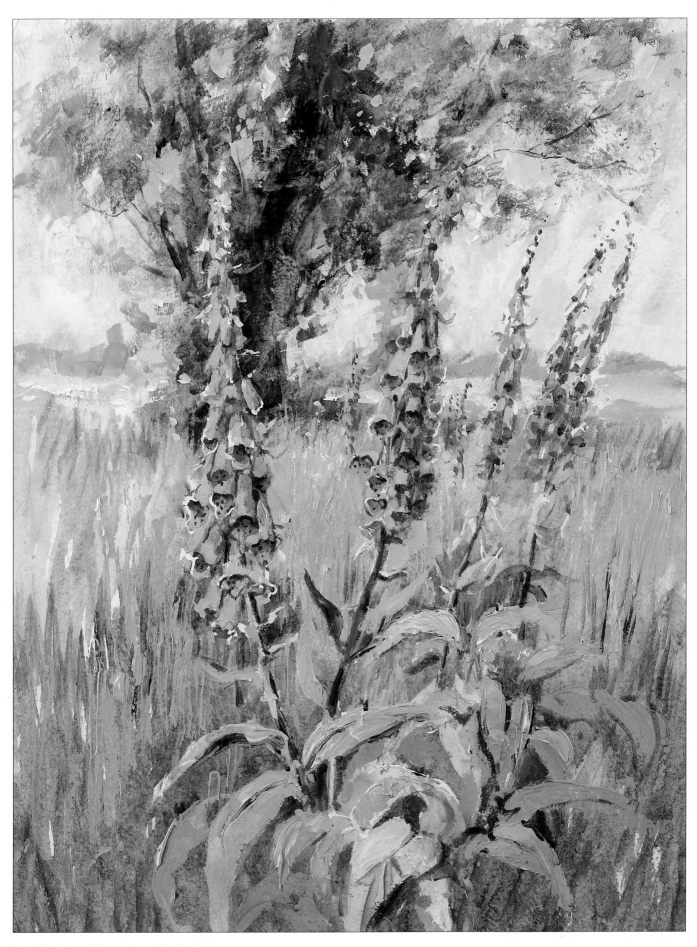

The finished painting, reduced in size.

Index

Cow Parsley and Cobwebs
40.5 x 30cm (16 x 12in)

The gorgeous spider's web on this cow parsley adds interest to the picture. Be creative and try different natural 'props' to add a special touch to your paintings.